RoCK
by
ROCK

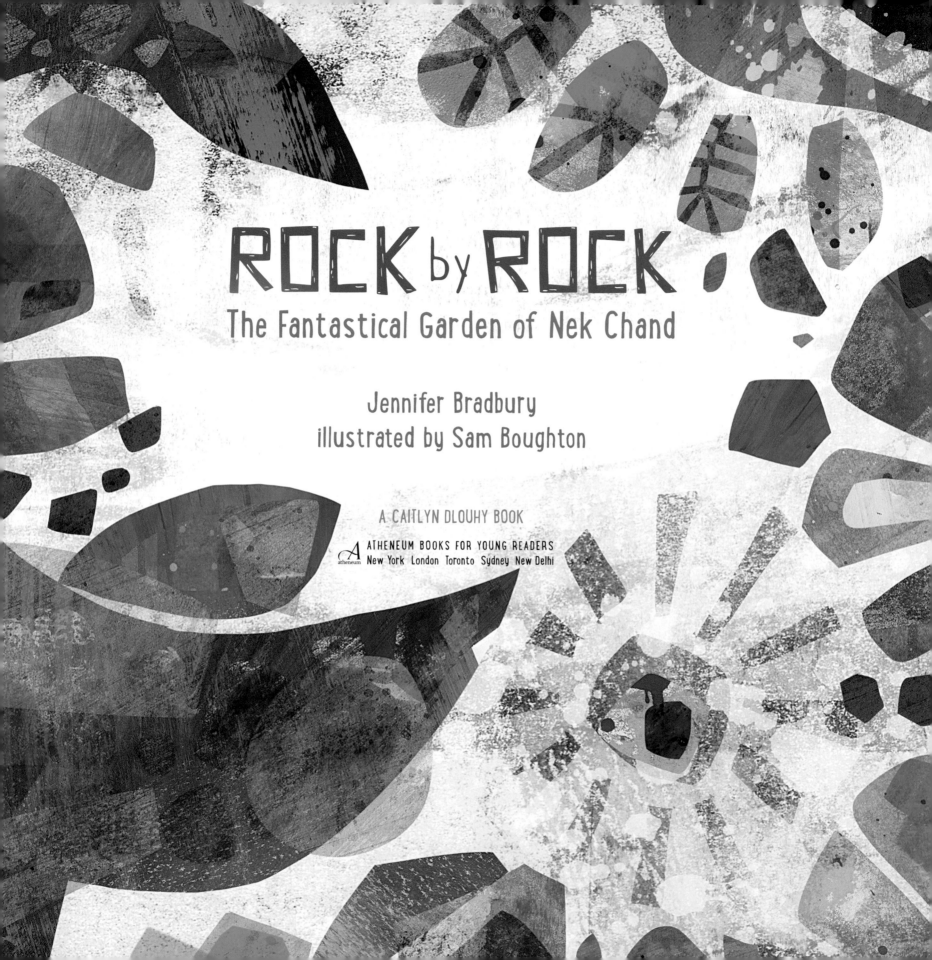

ROCK by ROCK
The Fantastical Garden of Nek Chand

Jennifer Bradbury

illustrated by Sam Boughton

A CAITLYN DLOUHY BOOK

ATHENEUM BOOKS FOR YOUNG READERS
New York London Toronto Sydney New Delhi

ATHENEUM BOOKS FOR YOUNG READERS
An imprint of Simon & Schuster Children's Publishing Division
1230 Avenue of the Americas, New York, New York 10020
Text copyright © 2021 by Jennifer Bradbury
Illustrations copyright © 2021 by Sam Boughton
Photo of white figures on page 44 and all photos on page 46
are courtesy of John Francis Cross of the Nek Chand Foundation.
Photo of people on swings on page 47 is by Adam Jones.
Photo of orange mosaic animals on page 44 and photo of waterfall on page 45
are by Rod Waddington.
Photo of red and blue birds on page 44 is by Vinayaraj.
Photo of the peacock mosaic on page 44 and photo of the elephant sculptures
on page 45 are courtesy of the author.
For information about special discounts for bulk purchases, please contact Simon & Schuster Special Sales at 1-866-506-1949 or business@simonandschuster.com.
The Simon & Schuster Speakers Bureau can bring authors to your live event.
For more information or to book an event, contact the Simon & Schuster Speakers Bureau at 1-866-248-3049 or visit our website at www.simonspeakers.com.
Book design by Debra Sfetsios-Conover
The text for this book was set in Itchy Handwriting.
The illustrations for this book were rendered digitally.
Manufactured in China
1120 SCP
First Edition
2 4 6 8 10 9 7 5 3 1
Library of Congress Cataloging-in-Publication Data
Names: Bradbury, Jennifer (Jennifer A.), author. | Boughton, Sam, illustrator.
Title: Rock by rock / Jennifer Bradbury, Sam Boughton.
Description: First edition. | New York : Atheneum Books for Young Readers, 2021. | "A Caitlyn Dlouhy Book." | Audience: Ages 4-8 | Audience: Grades K-1 |
Summary: "The true story of artist Nek Chand and how his secret—and illegal—art project became one of Indian's most treasured wonders"—Provided by publisher.
Identifiers: LCCN 2020013335 (print) | LCCN 2020013336 (eBook) | ISBN 9781481481823 | ISBN 9781481481830 (eBook)
Subjects: LCSH: Chand, Nek—Juvenile literature. | Public sculpture—India—Chandigarh (Union Territory)—Juvenile literature. | Rock gardens—India—Chandigarh (Union Territory)—Juvenile literature.
Classification: LCC NB1010.C42 B73 2021 (print) | LCC NB1010.C42 (eBook) | DDC 712/.6095455—dc23
LC record available at https://lccn.loc.gov/2020013335
LC eBook record available at https://lccn.loc.gov/2020013336

For Neera Puri
—J.B.

For Jon and Monty
—S.B.

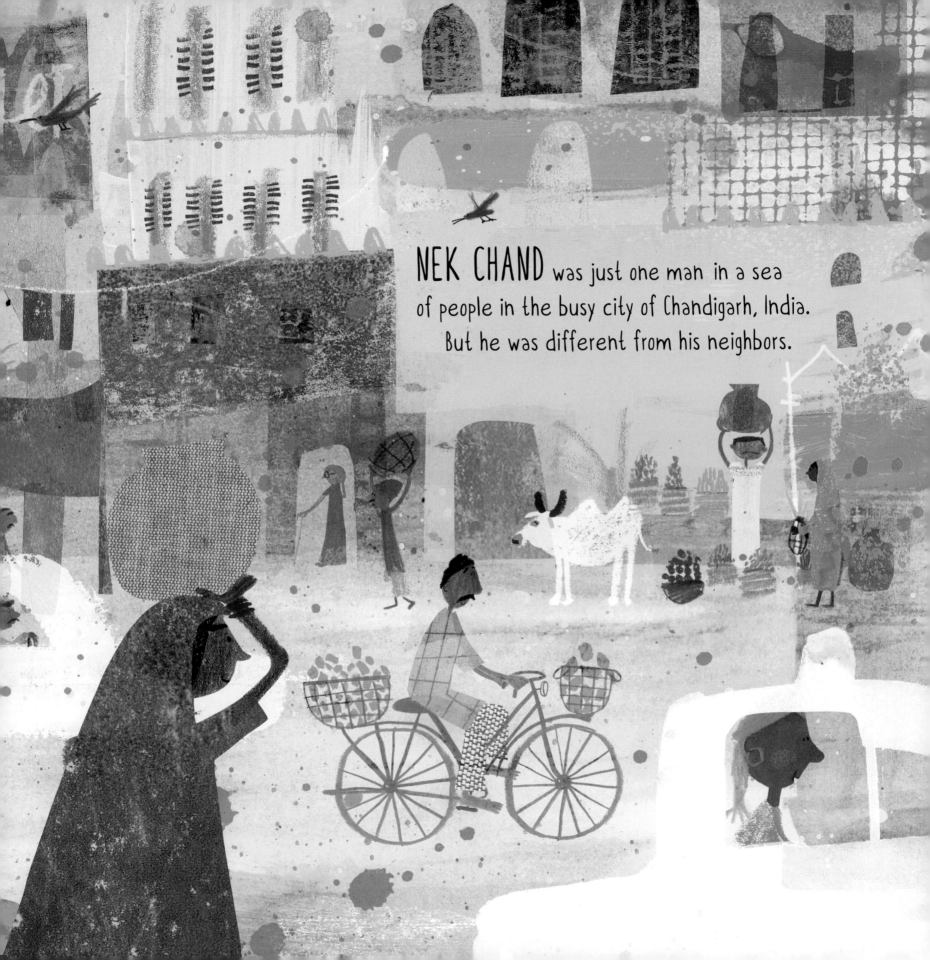

NEK CHAND was just one man in a sea of people in the busy city of Chandigarh, India. But he was different from his neighbors.

Why was he sifting through that pile of rubbish?

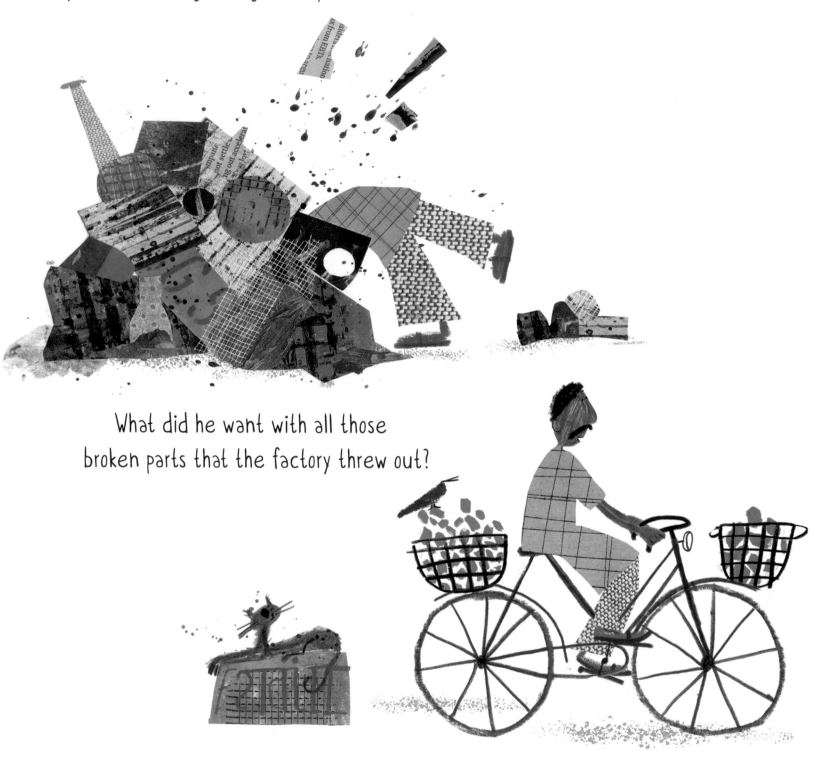

What did he want with all those
broken parts that the factory threw out?

Where could he be going with all those rocks?

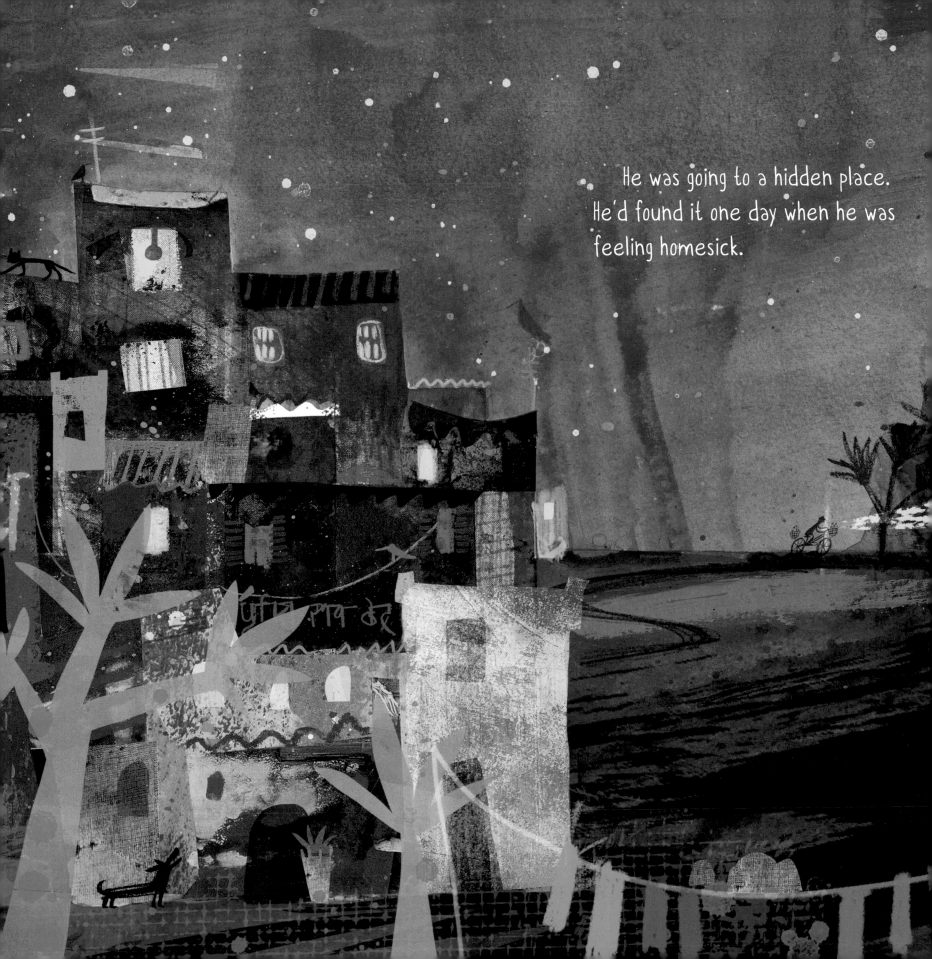

He was going to a hidden place.
He'd found it one day when he was
feeling homesick.

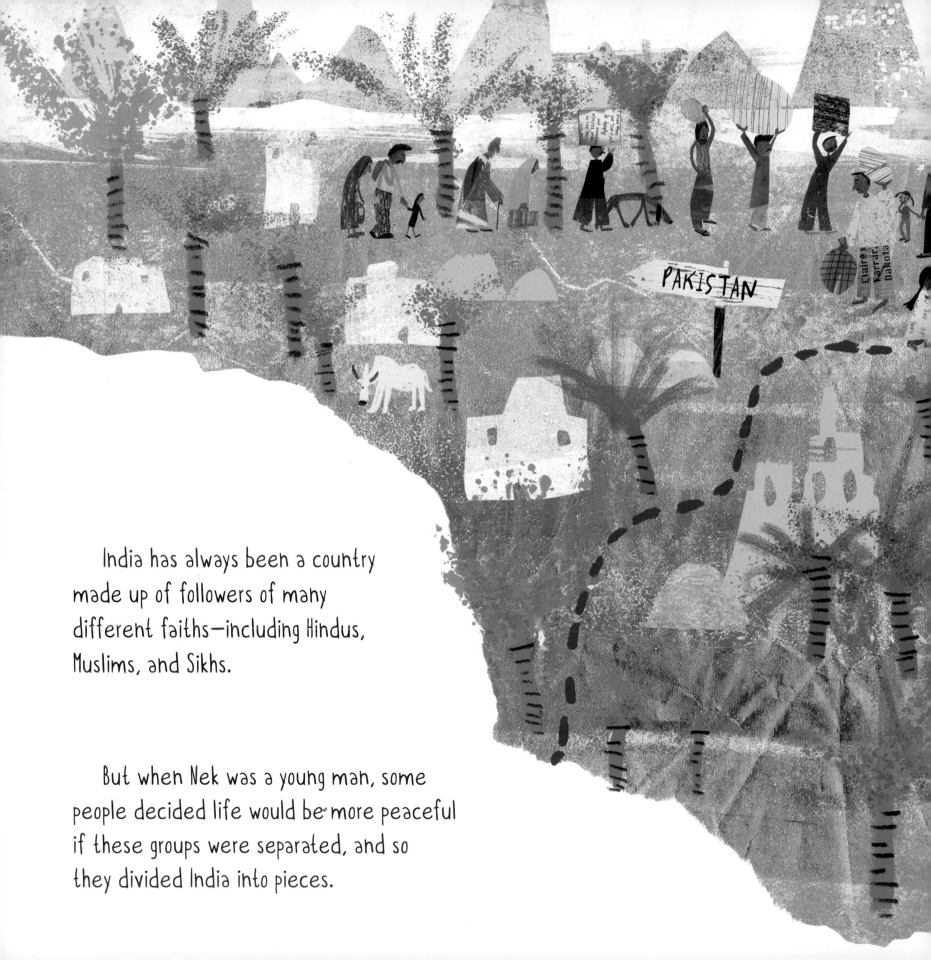

PAKISTAN

India has always been a country
made up of followers of many
different faiths—including Hindus,
Muslims, and Sikhs.

But when Nek was a young man, some
people decided life would be more peaceful
if these groups were separated, and so
they divided India into pieces.

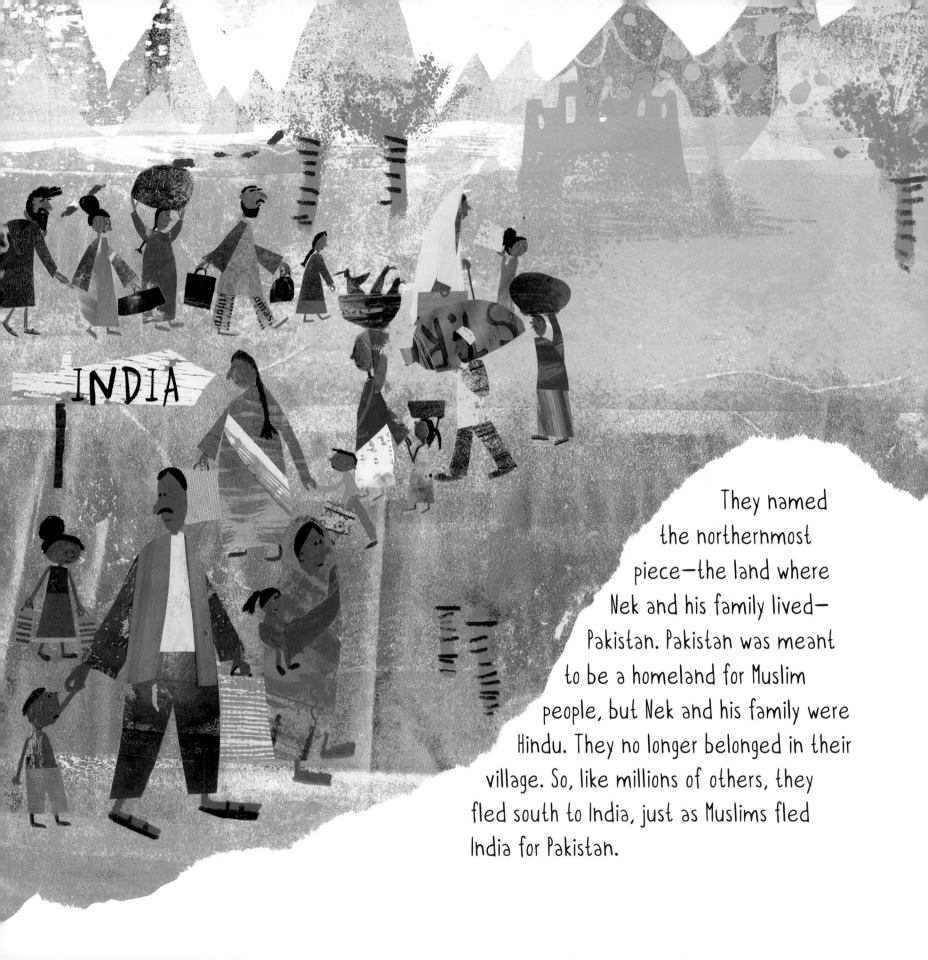

INDIA

They named
the northernmost
piece—the land where
Nek and his family lived—
Pakistan. Pakistan was meant
to be a homeland for Muslim
people, but Nek and his family were
Hindu. They no longer belonged in their
village. So, like millions of others, they
fled south to India, just as Muslims fled
India for Pakistan.

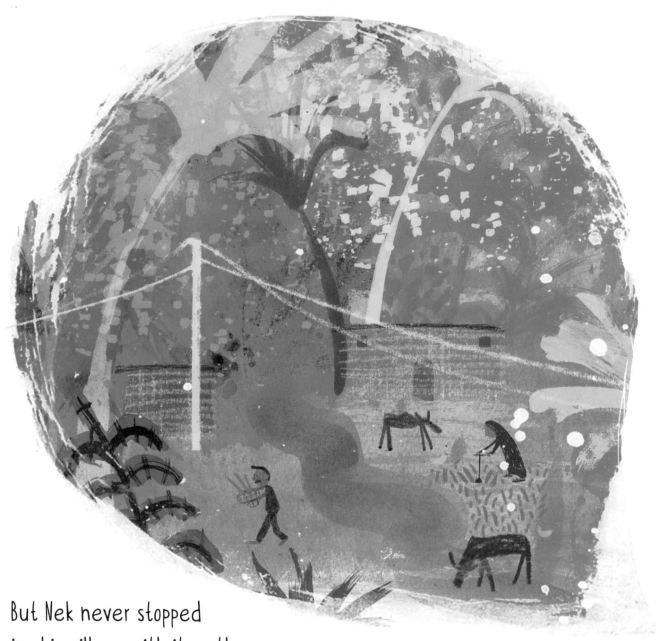

But Nek never stopped
missing his village with its paths
that turned to streams
during the rains and
the dense forests
full of rosewood trees.

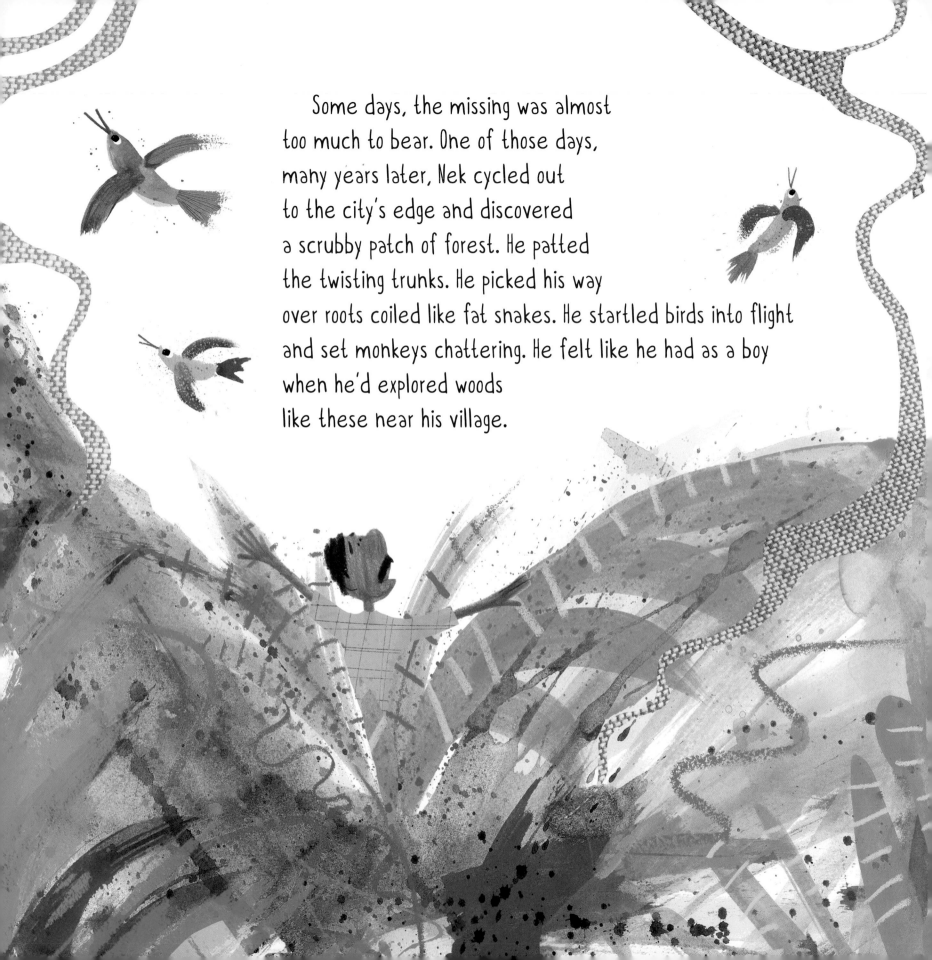

Some days, the missing was almost
too much to bear. One of those days,
many years later, Nek cycled out
to the city's edge and discovered
a scrubby patch of forest. He patted
the twisting trunks. He picked his way
over roots coiled like fat snakes. He startled birds into flight
and set monkeys chattering. He felt like he had as a boy
when he'd explored woods
like these near his village.

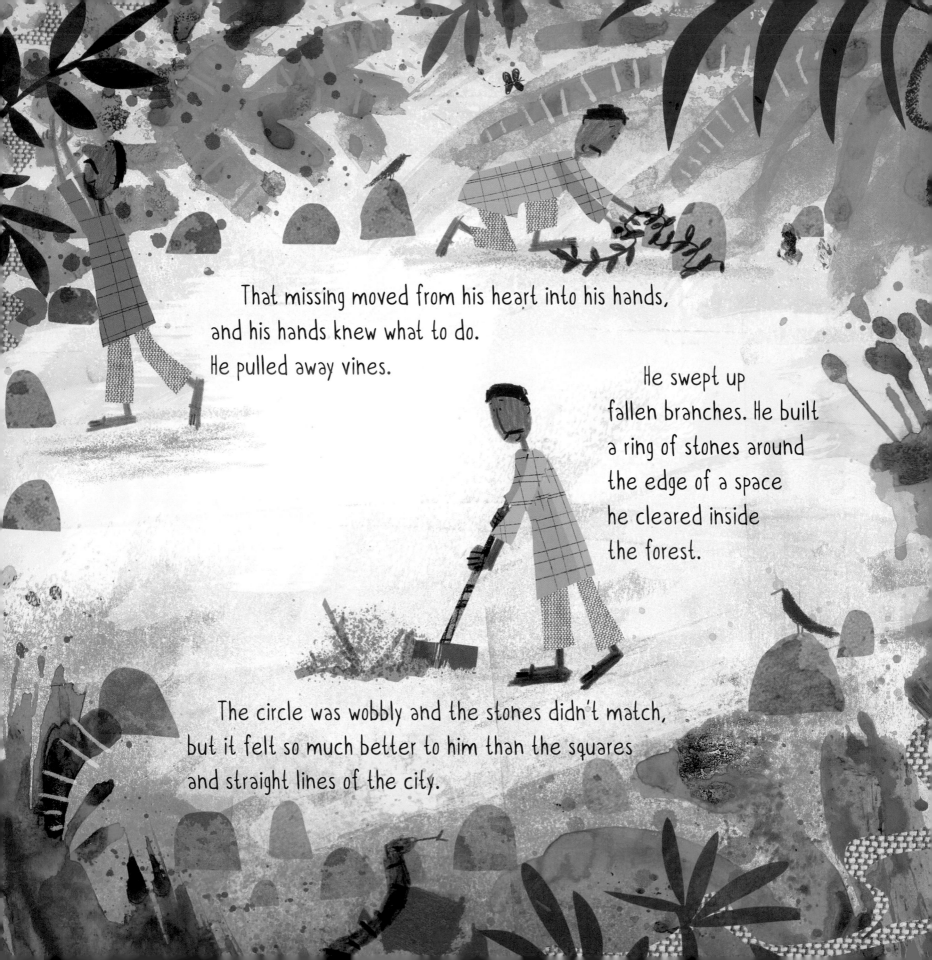

That missing moved from his heart into his hands,
and his hands knew what to do.
He pulled away vines.

He swept up
fallen branches. He built
a ring of stones around
the edge of a space
he cleared inside
the forest.

The circle was wobbly and the stones didn't match,
but it felt so much better to him than the squares
and straight lines of the city.

After long days at his job helping build new roads for the city, he collected stones that the road crews dug up and cast aside as they laid new pavement.

Nek loaded them onto the back of his bicycle, pedaled many miles out to his hidden place, and added them to the ring, or lined a new path.

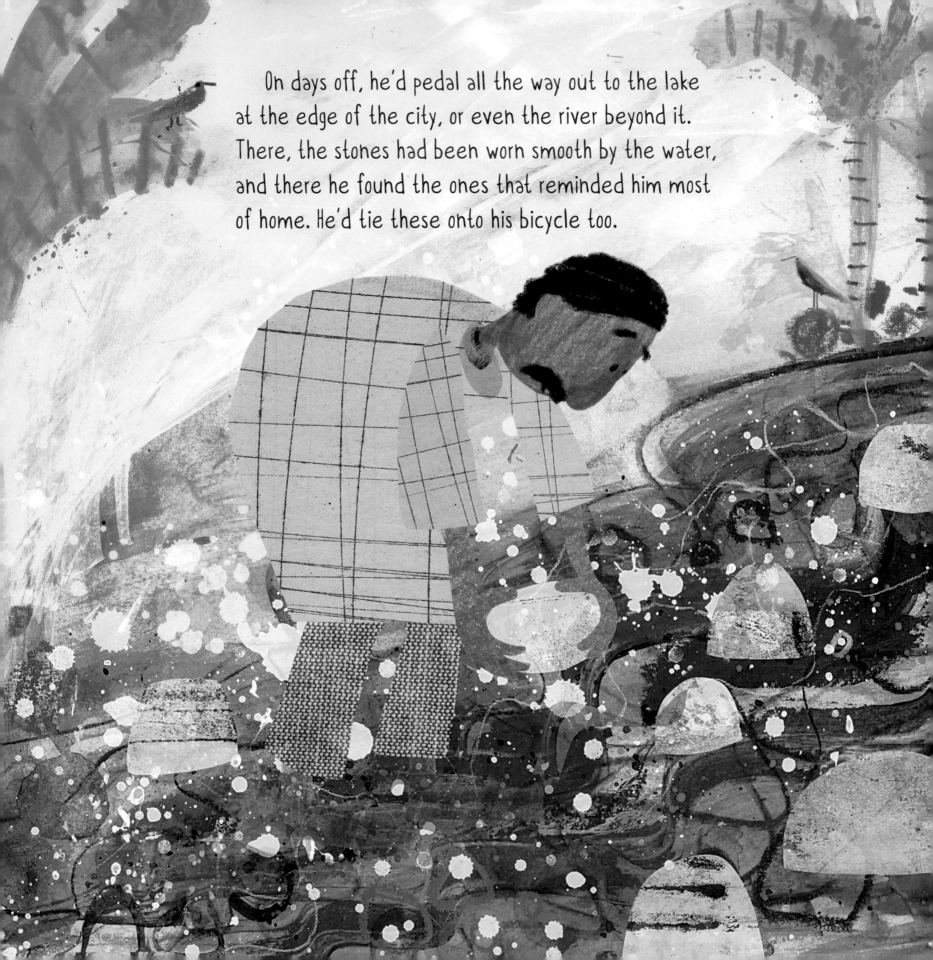

On days off, he'd pedal all the way out to the lake at the edge of the city, or even the river beyond it. There, the stones had been worn smooth by the water, and there he found the ones that reminded him most of home. He'd tie these onto his bicycle too.

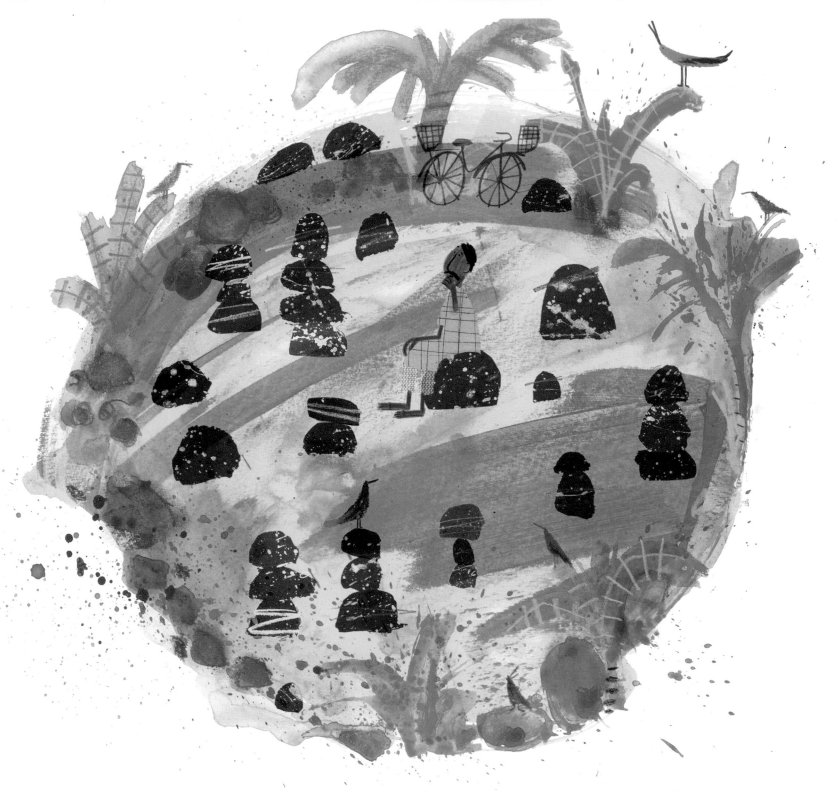

Soon he had so many rocks that his hidden place was like a garden of stones.
He wondered if he could do more than arrange the rocks. He wondered if he could
make something from them.

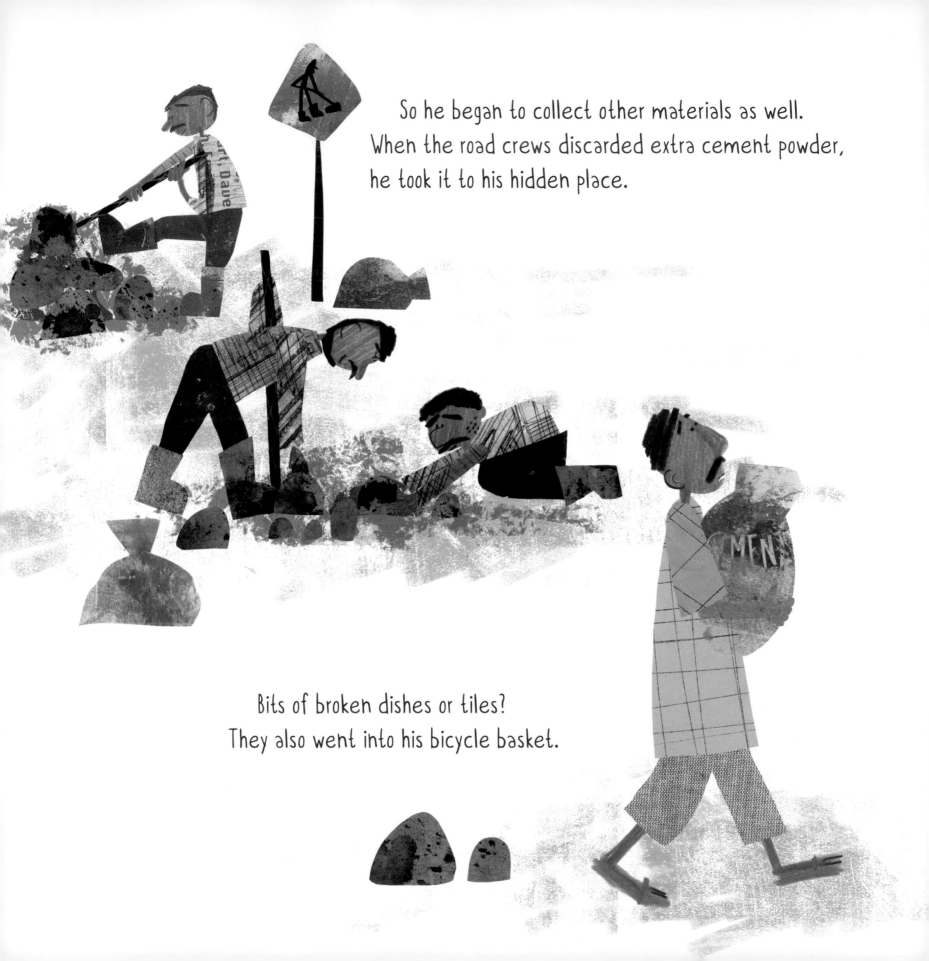

So he began to collect other materials as well.
When the road crews discarded extra cement powder,
he took it to his hidden place.

Bits of broken dishes or tiles?
They also went into his bicycle basket.

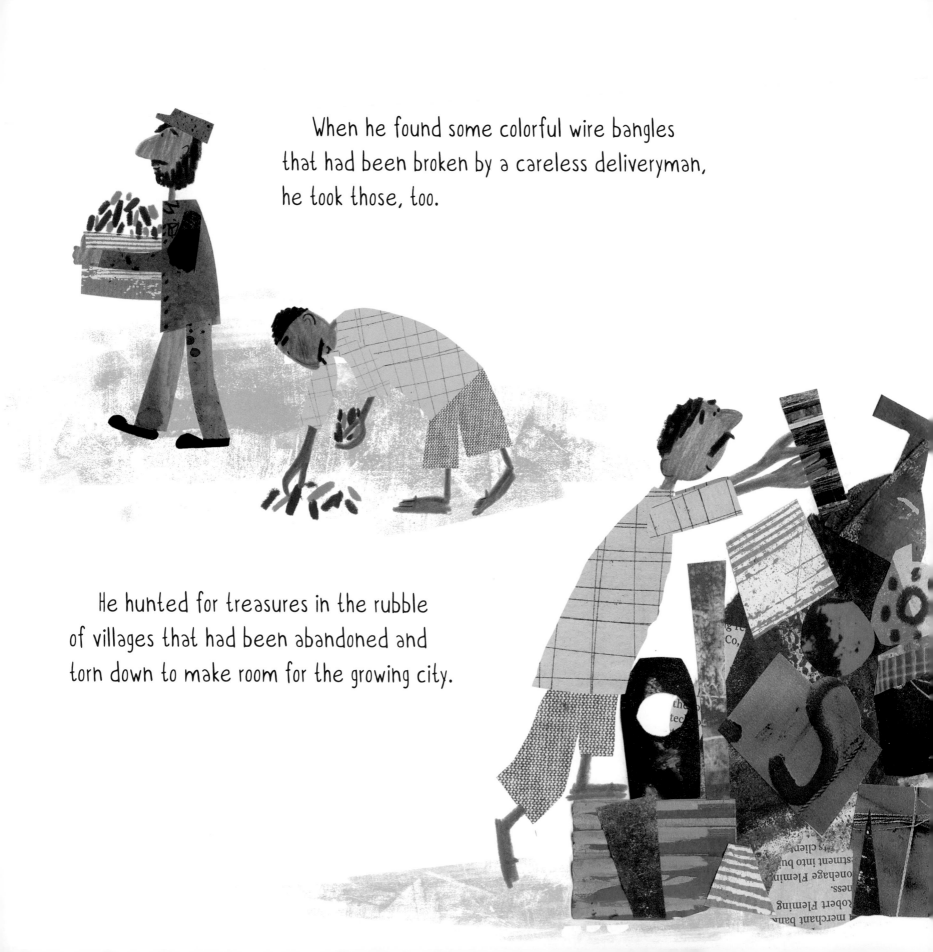

When he found some colorful wire bangles
that had been broken by a careless deliveryman,
he took those, too.

He hunted for treasures in the rubble
of villages that had been abandoned and
torn down to make room for the growing city.

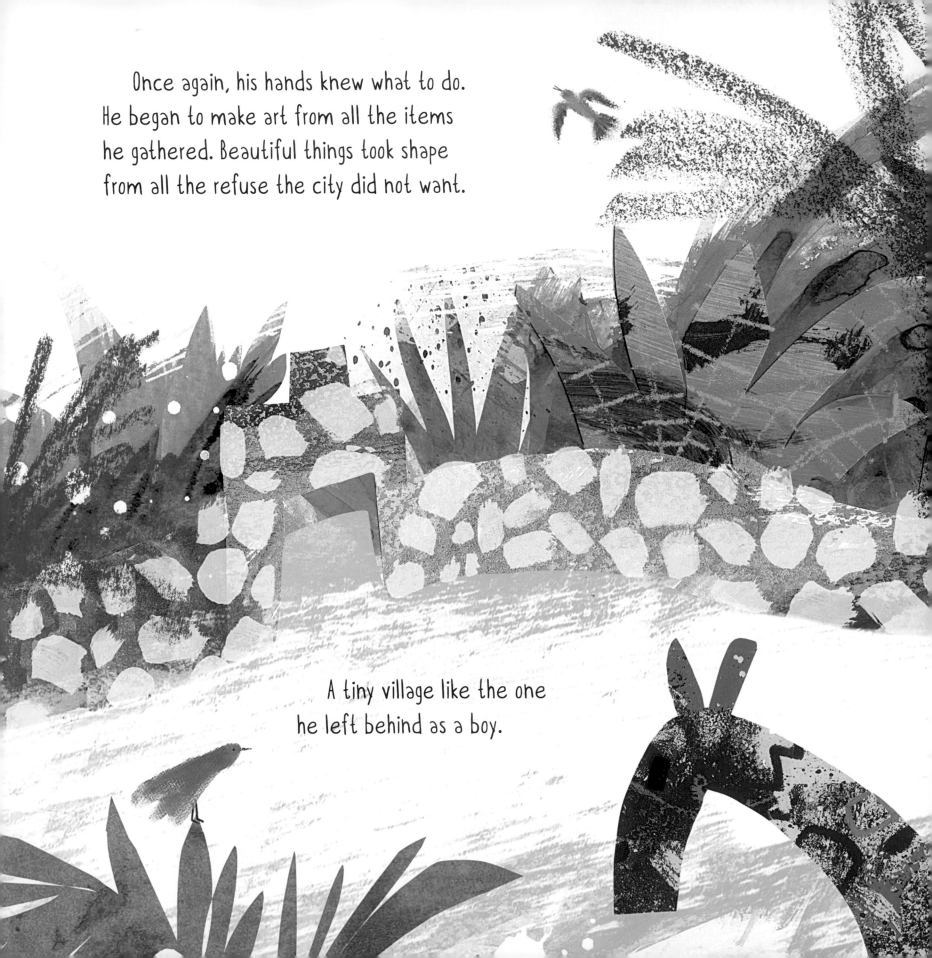

Once again, his hands knew what to do. He began to make art from all the items he gathered. Beautiful things took shape from all the refuse the city did not want.

A tiny village like the one he left behind as a boy.

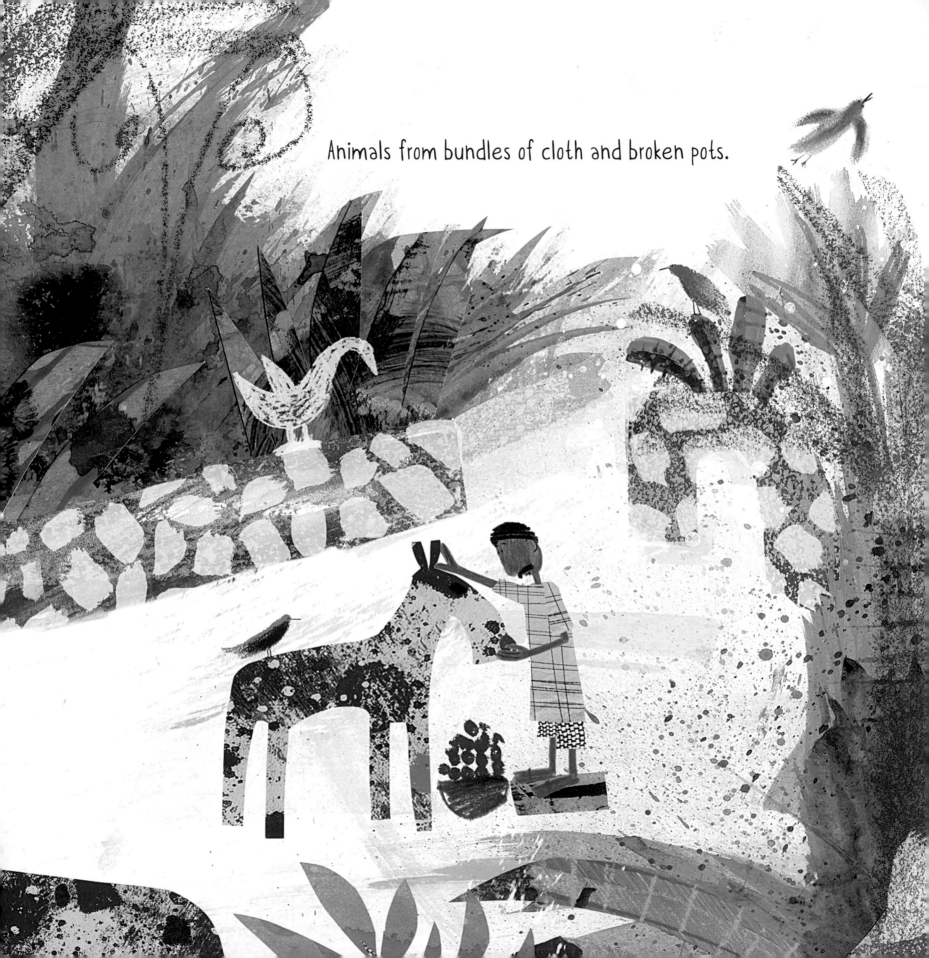

Animals from bundles of cloth and broken pots.

An army of laughing soldiers fashioned from construction wire, concrete, and broken plates.

Graceful dancing ladies, the broken bangle pieces artfully arranged to adorn them in colorful saris.

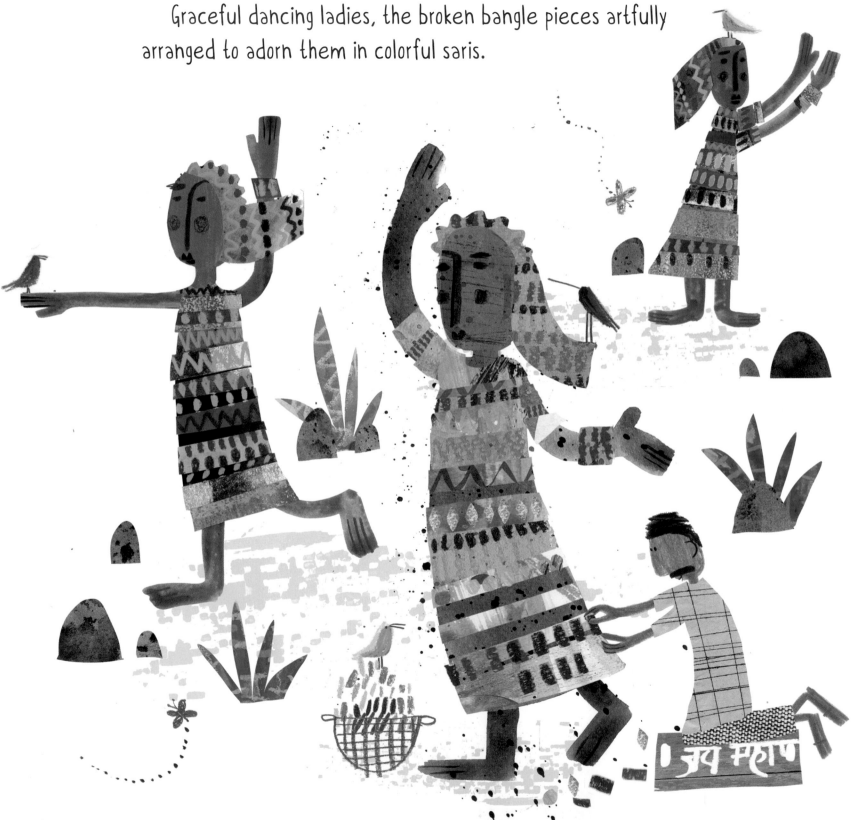

Walls from old cement and burlap bags, their doorways placed low, so that each time Nek passed from one space to another, he was reminded to be humble.

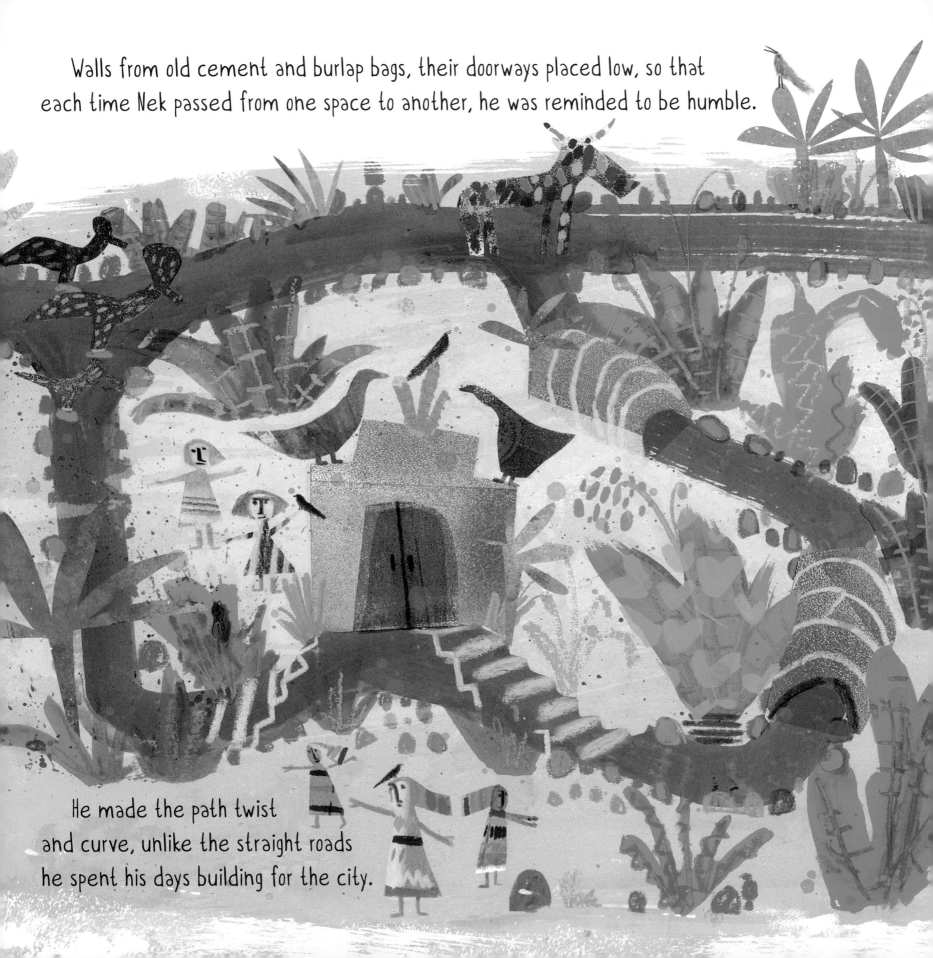

He made the path twist and curve, unlike the straight roads he spent his days building for the city.

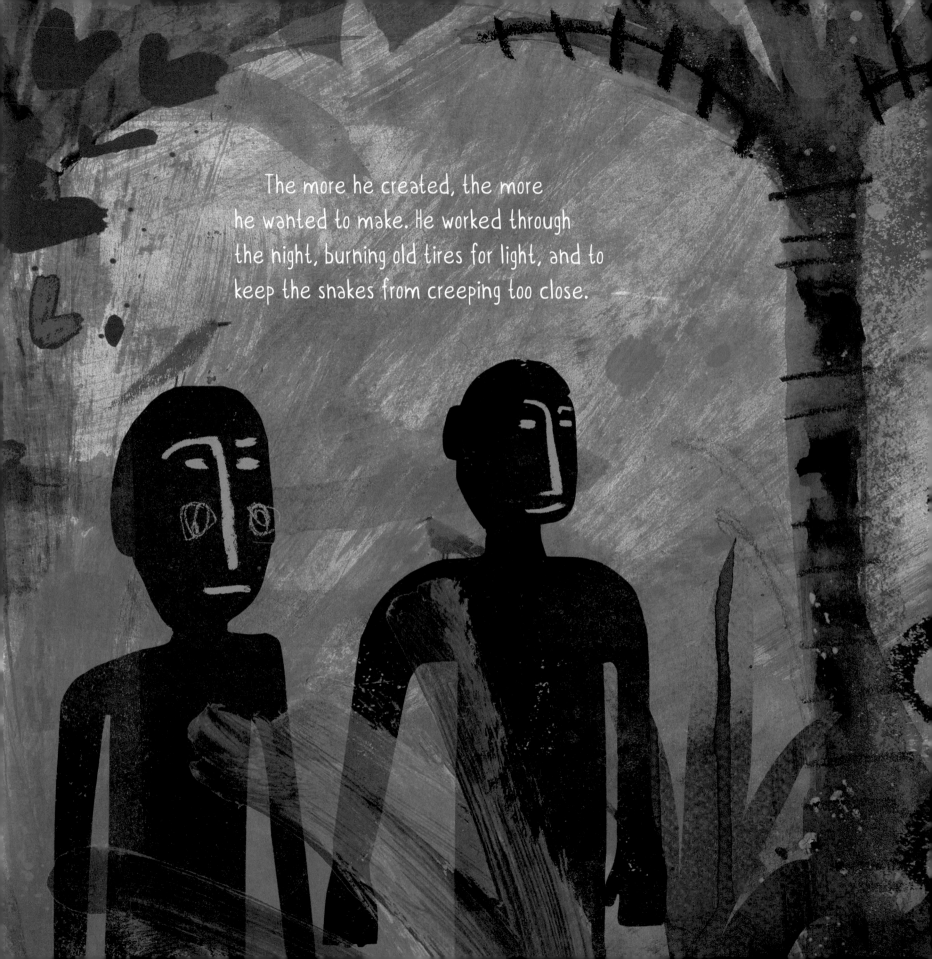

The more he created, the more
he wanted to make. He worked through
the night, burning old tires for light, and to
keep the snakes from creeping too close.

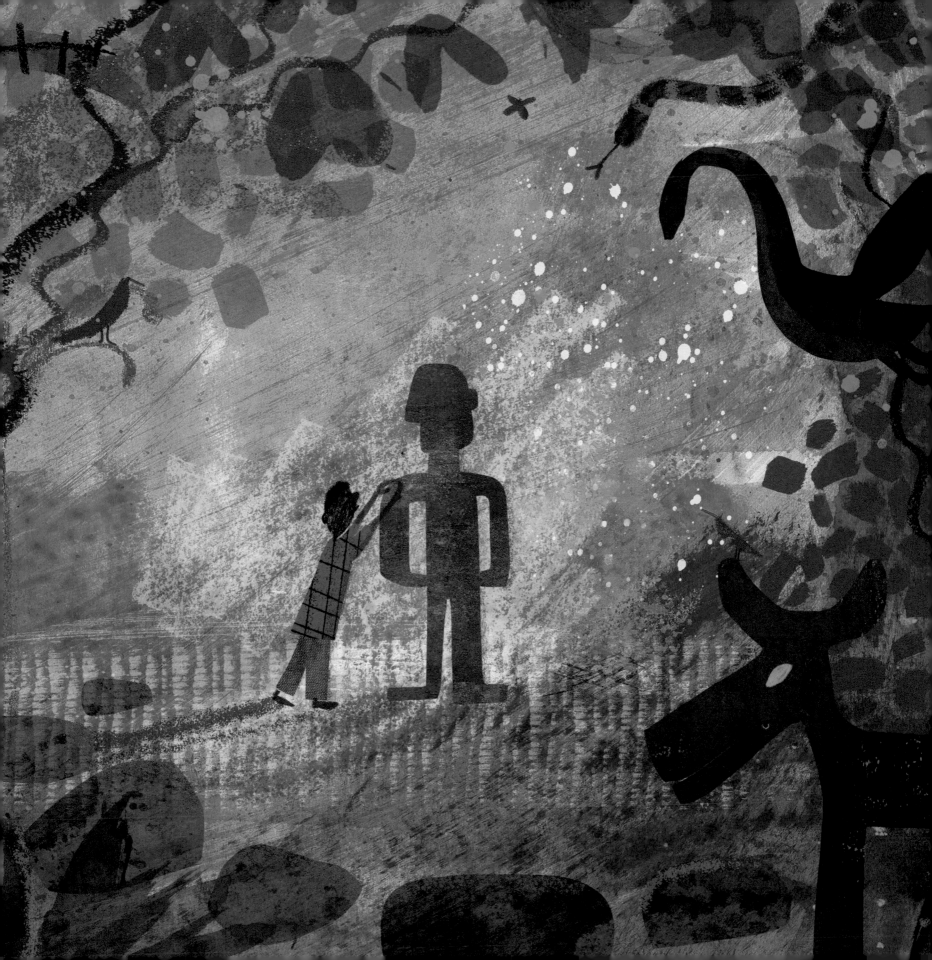

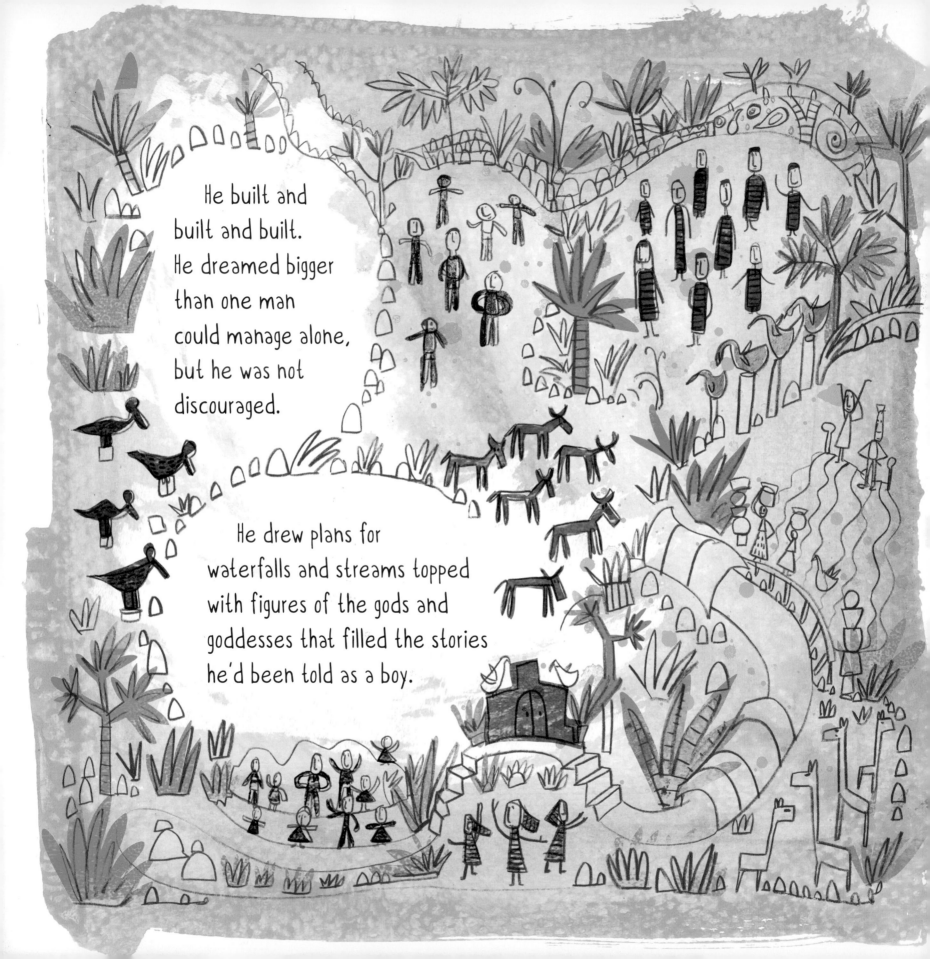

He built and
built and built.
He dreamed bigger
than one man
could manage alone,
but he was not
discouraged.

He drew plans for
waterfalls and streams topped
with figures of the gods and
goddesses that filled the stories
he'd been told as a boy.

As his garden grew in secret, his heart grew fuller,
happier than it had been in a long, long time.

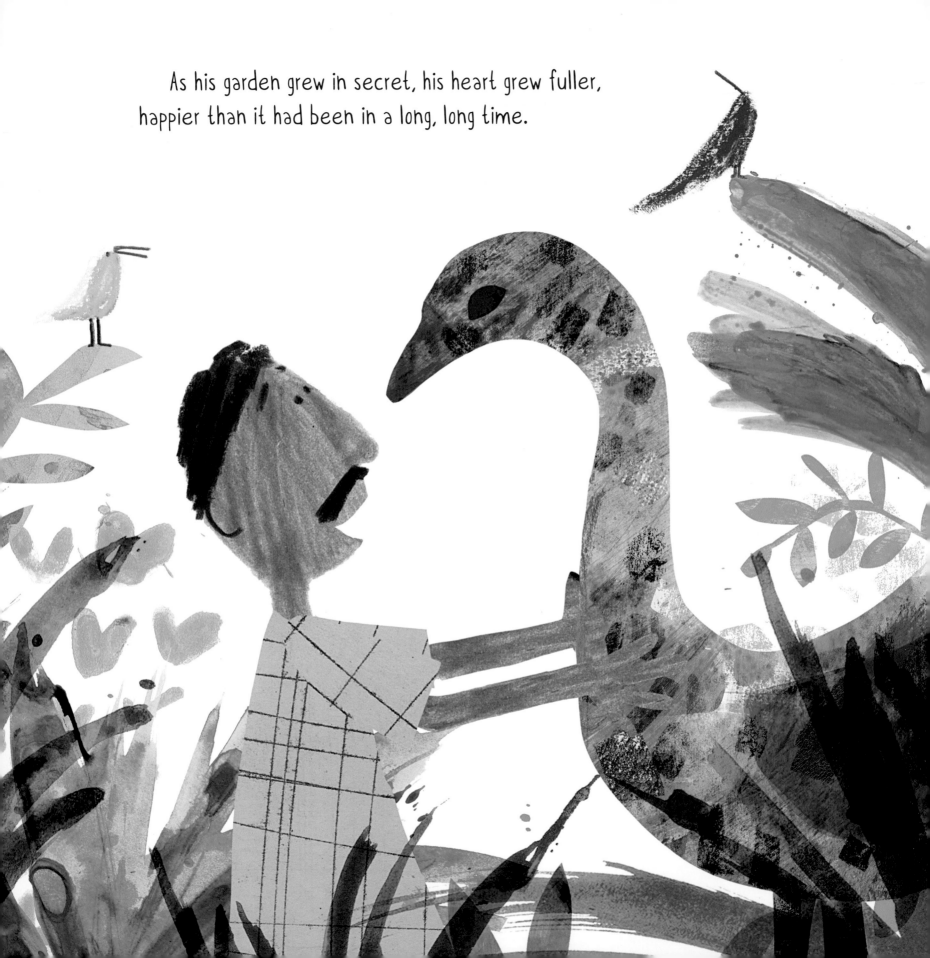

But the city, with its straight lines and long streets and crowded squares, was growing too.

One day another crew of workmen began laying out the path for a new road. They hacked and slashed their way through the stand of scrubby forest at the edge of the city.

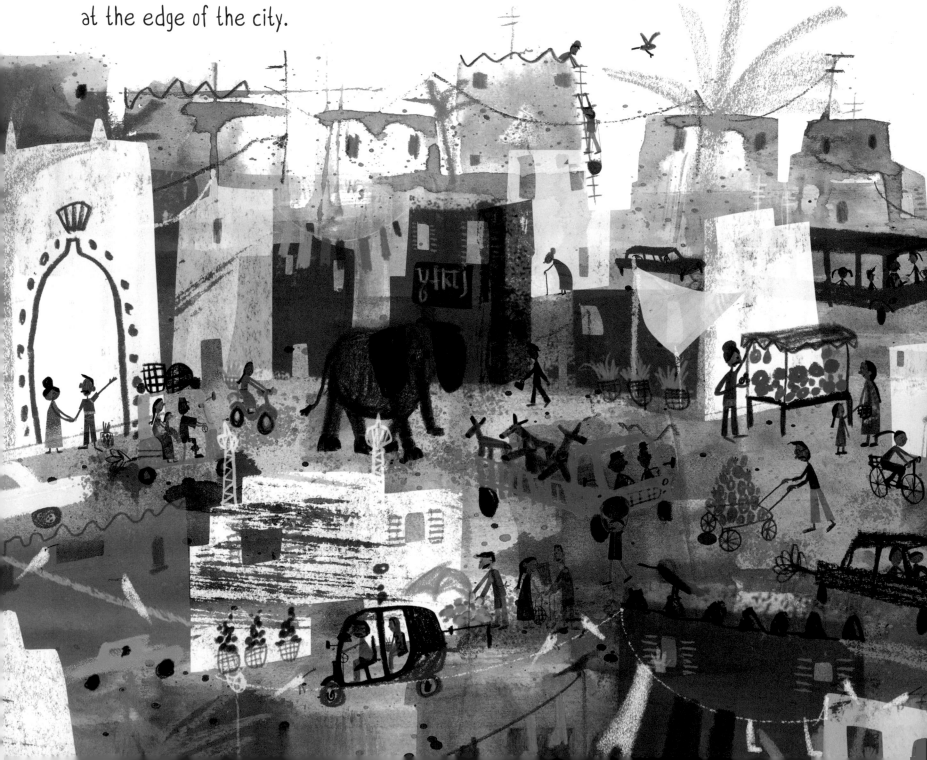

Then they stumbled into Nek Chand's secret garden.

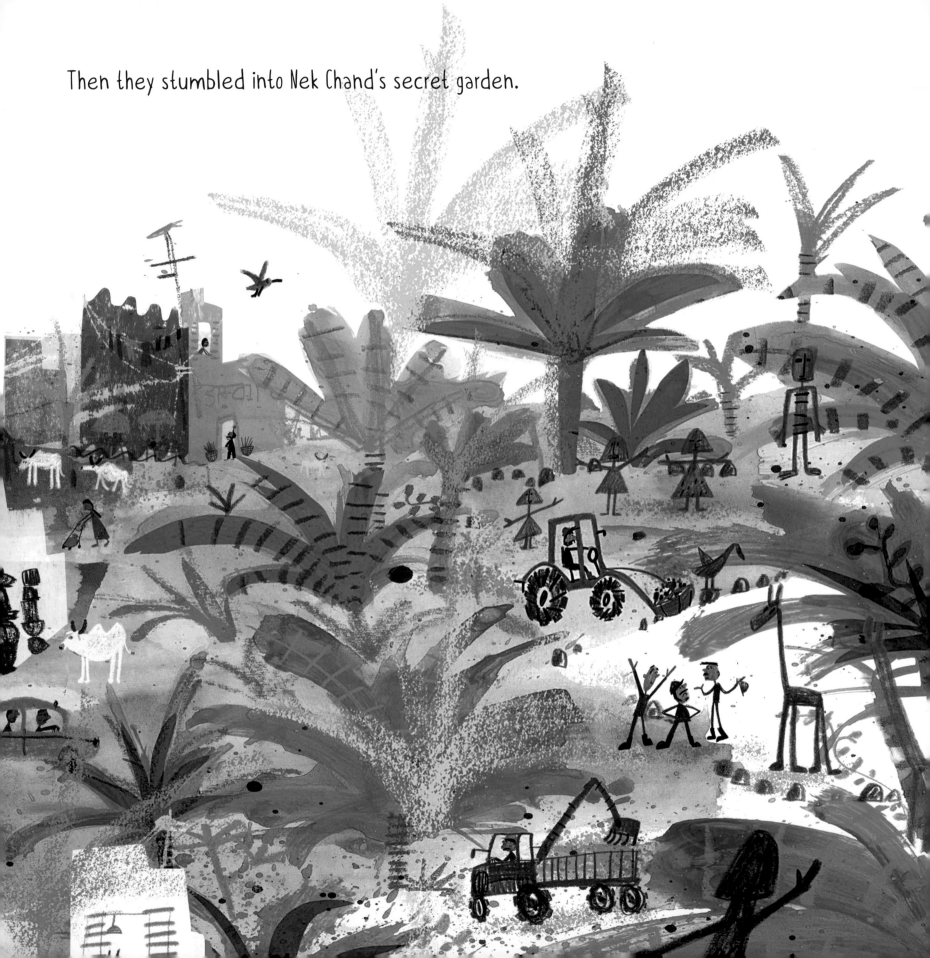

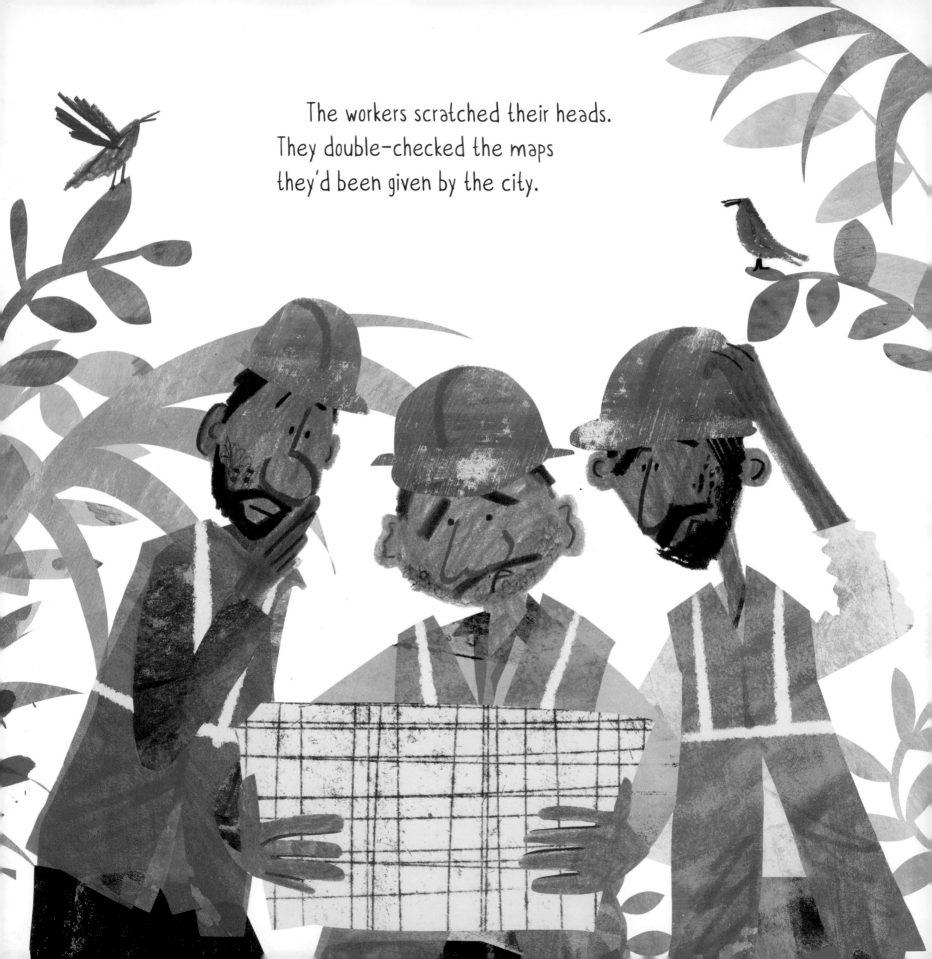

The workers scratched their heads.
They double-checked the maps
they'd been given by the city.

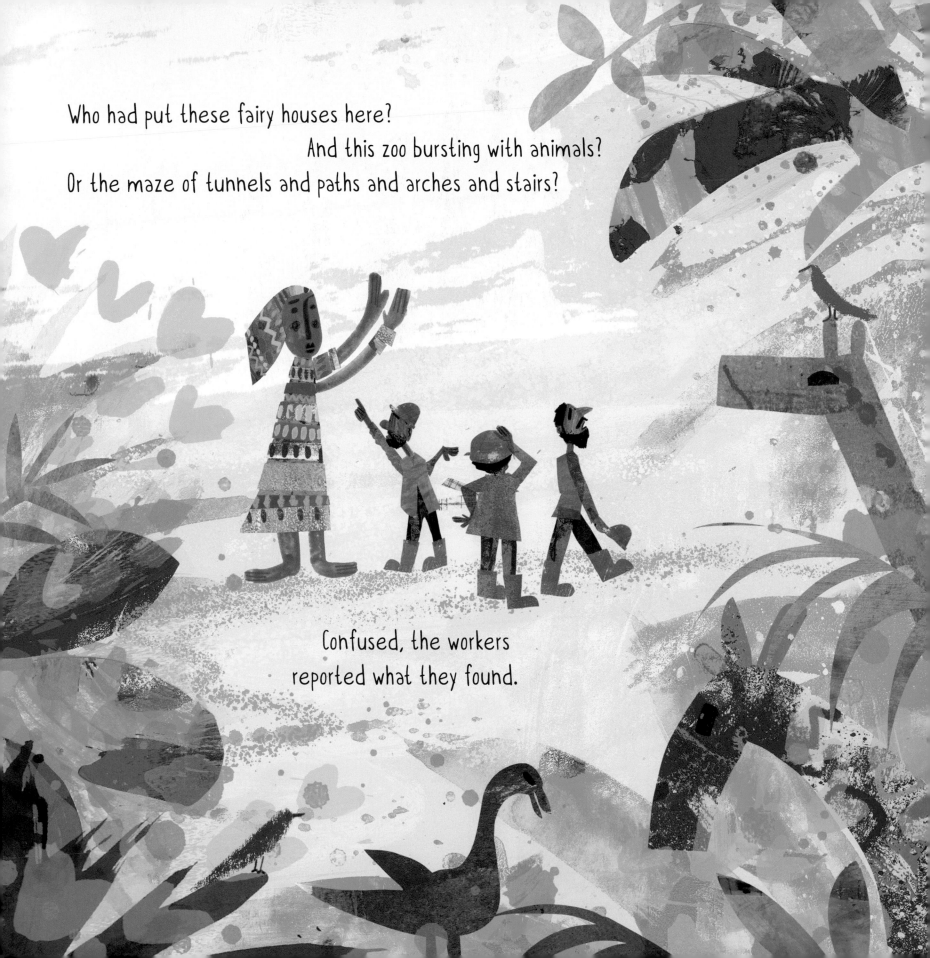

Who had put these fairy houses here?

And this zoo bursting with animals?

Or the maze of tunnels and paths and arches and stairs?

Confused, the workers
reported what they found.

Though he loved his garden, Nek had always expected that a day would come when he would be forced to give it up. So he came forward and explained what he'd been doing in the forest.

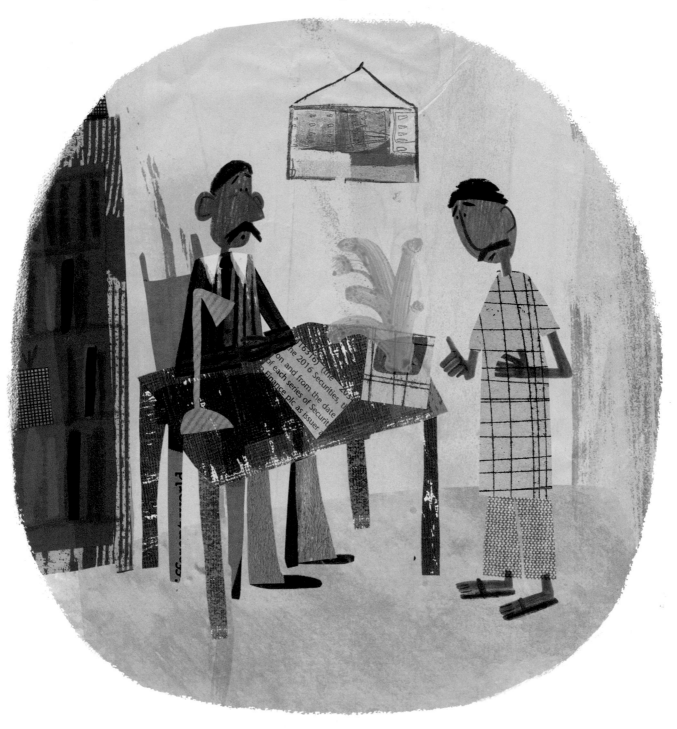

But instead of destroying his garden, many of the city's leaders were enchanted by Nek's creations! They wanted to see it grow. They abandoned their plans for this portion of the growing city. They asked Nek to leave his job building roads so he could carry on with his rock garden. They even gave him workers to help. Together, they dug wells and built a waterfall. They built giant swings and a theater.

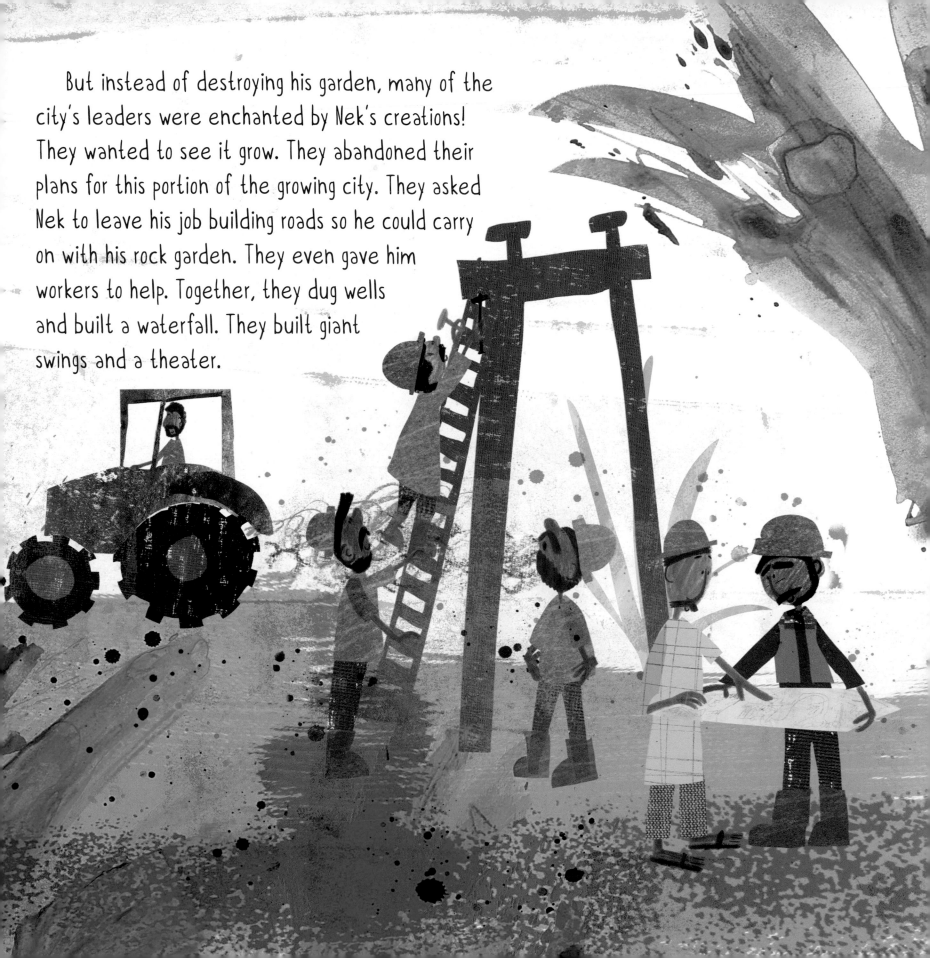

Soon people from all over the city, all over India, and all over the world came to visit the garden. They smiled at the laughing army, and they skipped around the dancing ladies and little houses. Children brought items their families had thrown out to see if Nek could use them in his sculptures. His garden grew.

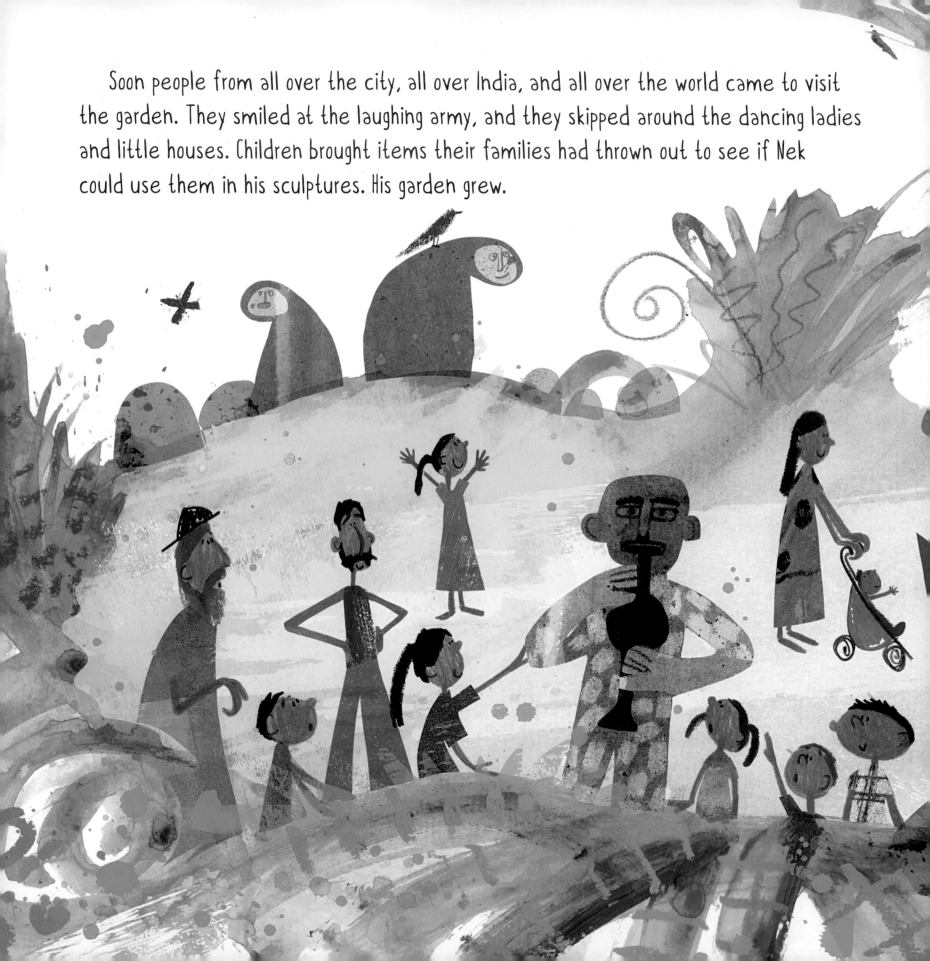

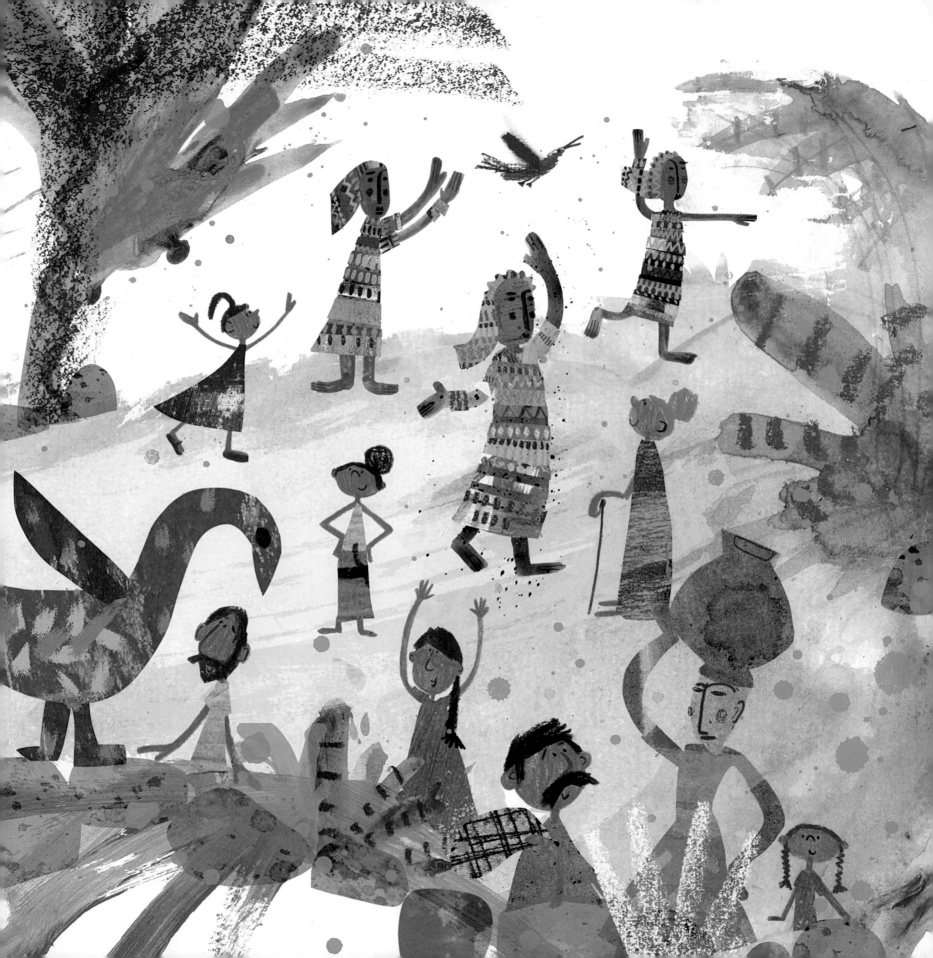

But not everyone loved what Nek had made.
As more people came to see the garden and the man who'd created it,
one city official grew envious.

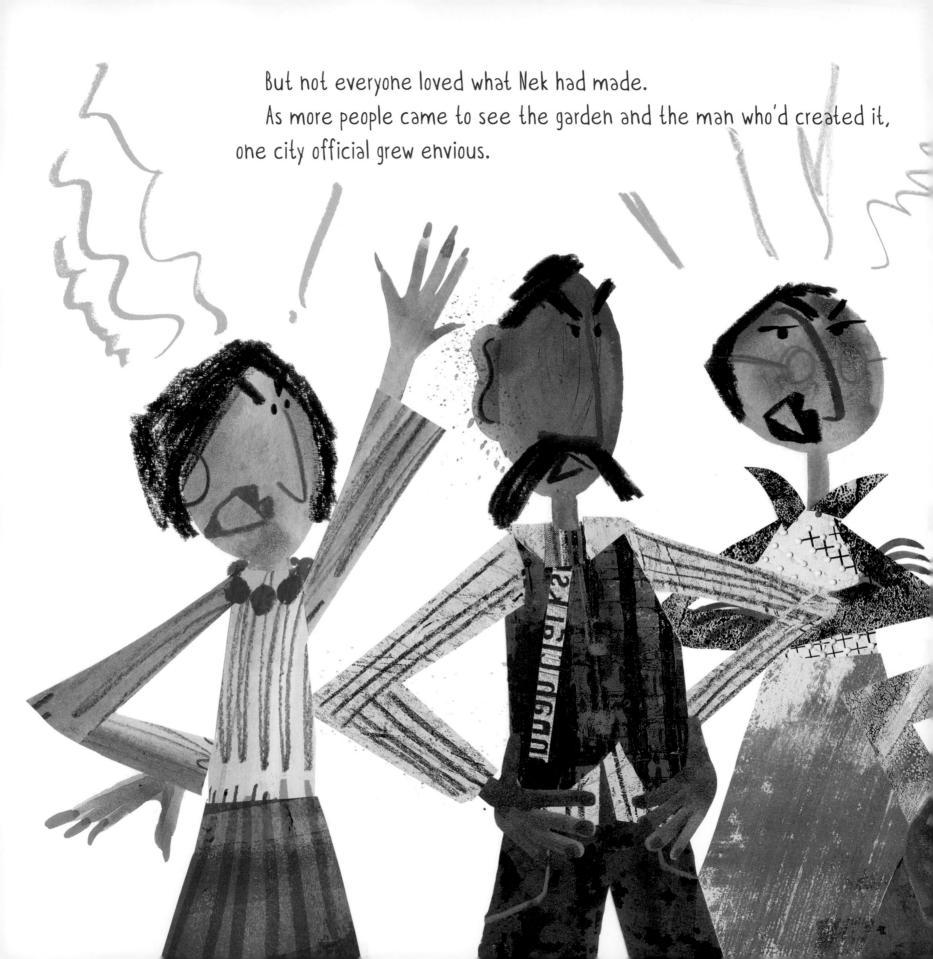

Why should a lowly road builder be allowed to take land that did not belong to him? Why should he be permitted to take cement and boards and materials that belonged to the city, no matter that they were going to be thrown away?

And why should important, busy people be expected to take their time and wander through Nek's garden like common people? Stooping through Nek's silly, small doorways; climbing up and down so many stairs?

This city official grumbled and complained until some others were convinced. Together they made a plan.

They ordered that a road be built through the garden.

This road would be open only to cars carrying very important people who couldn't be bothered to walk and stoop and get lost in the garden the way Nek intended.

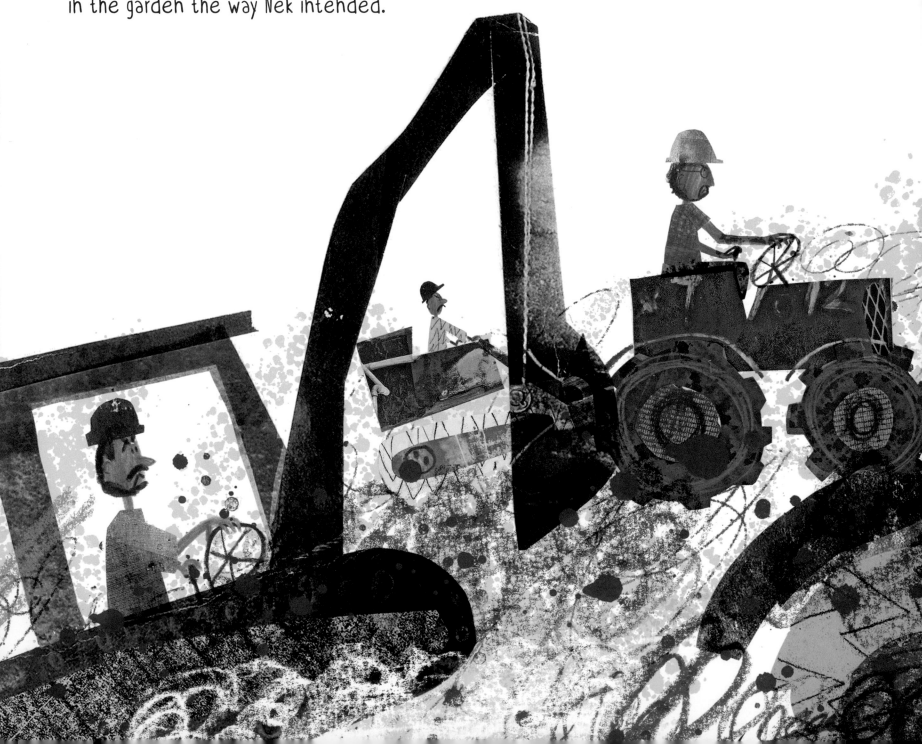

Machines arrived to knock down
the walls and lay the pavement.

What could Nek do? He was
only one man, after all.
Or was he?

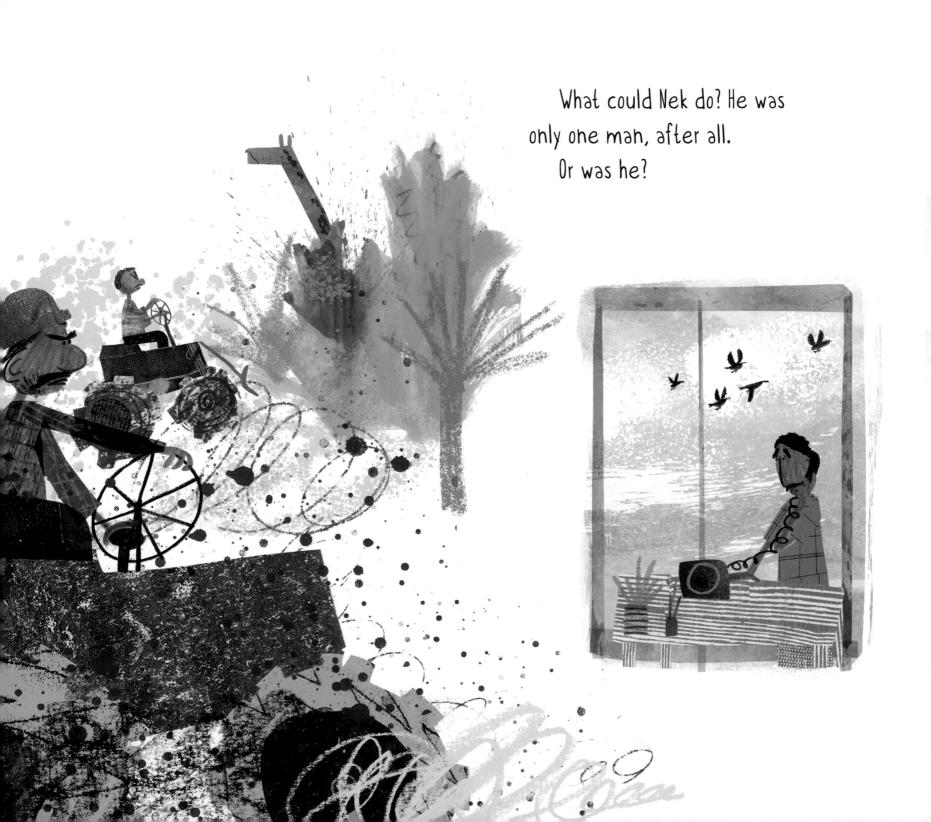

A new army came forth.
Schoolchildren, teachers, doctors, rickshaw drivers, and shopkeepers encircled the garden. Old and young, rich and poor wanted to protect what Nek had created.

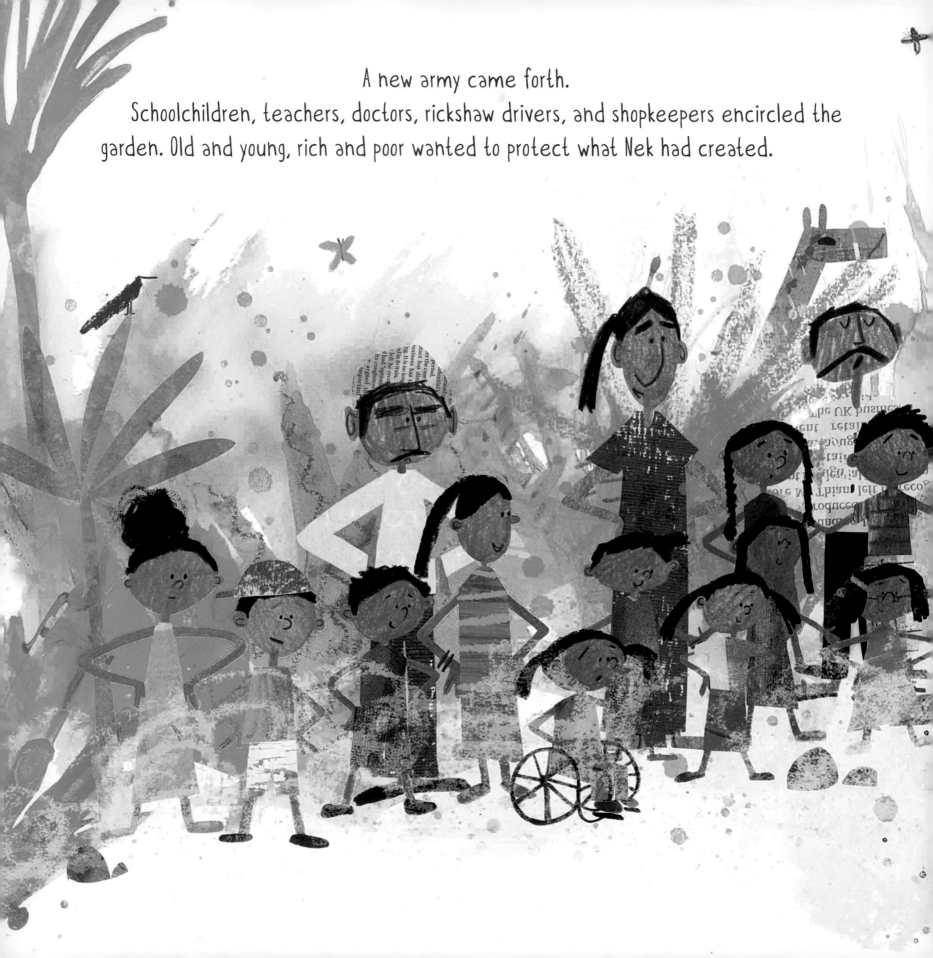

Together they linked arms, clasped hands, and stood as silent and staring as Nek's statues while the demolition equipment growled and smoked.

They refused to move until the bulldozers were shut off and the crews sent home.

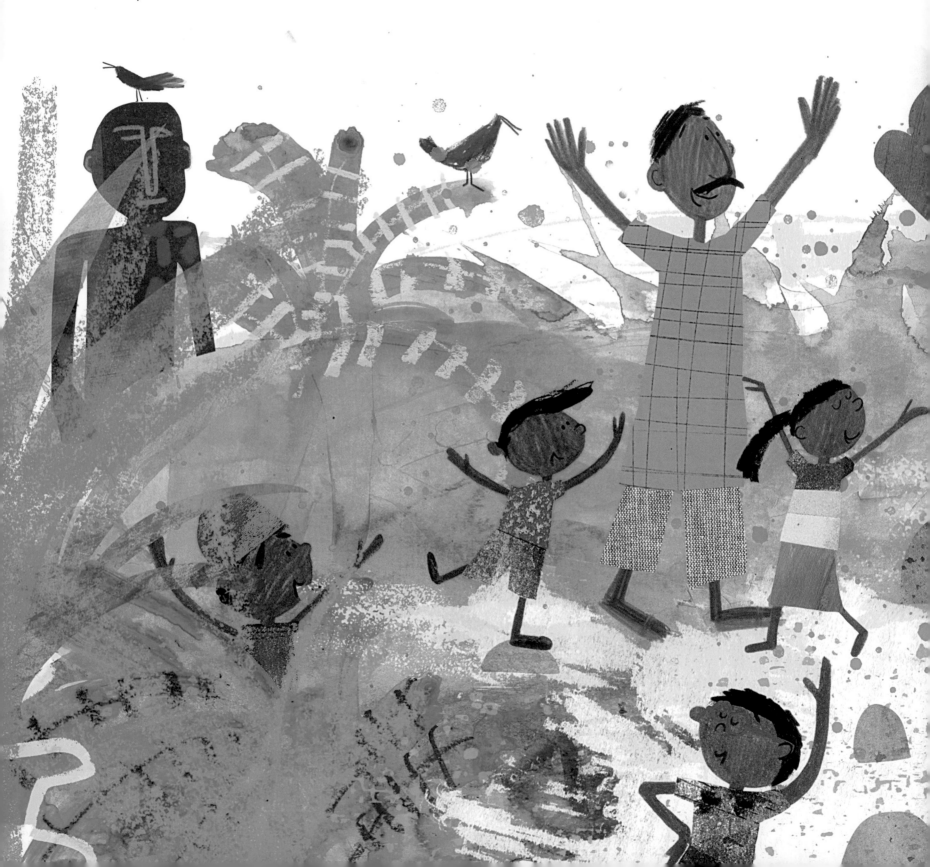

The road was never built.

And Nek's garden continued to grow.

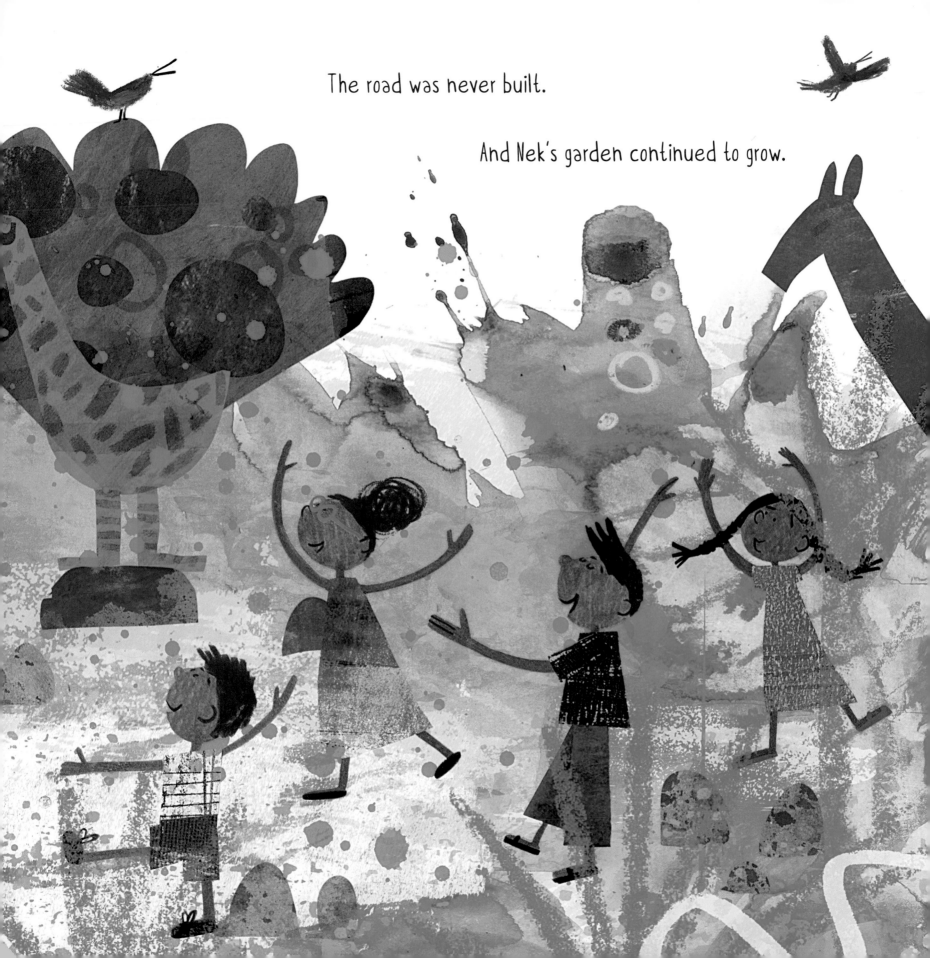

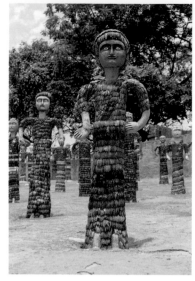
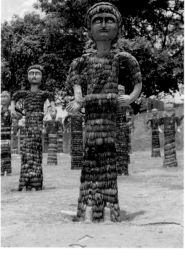
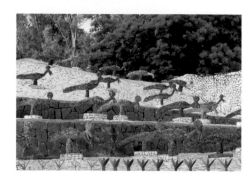
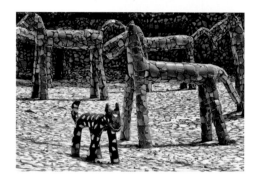

A NOTE

EACH DAY an estimated five thousand people come from all over the world to visit the Rock Garden. These visitors pay a small admission fee, enter through a tiny cramped doorway, and take the journey that Nek Chand Saini began so long ago. In 2005, I was one of those visitors. I lived in Chandigarh while teaching at a local high school. One of the first places my new friends took me was Nek's garden. His art and his story captivated me. And his need to create inspired me.

Nek was among the millions of refugees displaced by the partition of India and Pakistan in 1947. Before and during the division of the country, upheaval and violence gripped people on both sides of the new borders. He and his family left their ancestral home and started over. His parents died within months of each other, less than two years after their relocation. "Partition devoured them," Nek said. "Had there been no Partition, I am sure they would have lived many more years." He did his best to move on, finding work as a civil servant and marrying. He and his wife eventually settled in Chandigarh. Chandigarh was a brand-new planned city built over the rubble of dozens of other villages that had been demolished after the events of Partition. Because the city was near to the new border, many who came to live there had been directly affected by the events of Partition. In that sense, Nek was at home among hundreds of thousands who had also suffered the loss of their homeland.

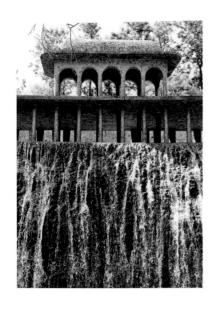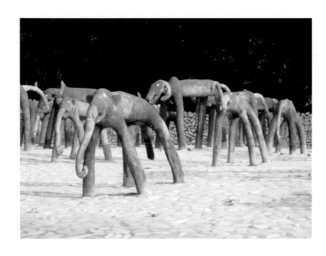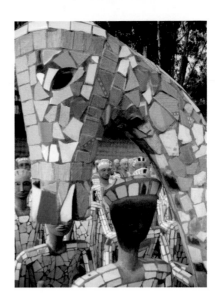

But Nek's response to that loss was unique. He was not a trained artist in any way. He had no plan when he first began building the garden. When asked about his work, Nek said, "I never wanted to do all this. I never dreamt it would become what it has. It was my hands that did the wanting for me. Probably due to my peasant roots. I like to plow, to till the soil, to dig furrows. I've never stopped, that's all." Through working the land and then creating art to dwell in that land, Nek found peace for himself and gave hope to millions of others who have seen his work or heard his story. His garden grew to cover nearly forty acres (that's about thirty American football fields!), and he worked on it for more than sixty years (eighteen of those on his own and in secret) before his death in 2015.

I feel very blessed to have written two stories about Nek Chand—this one, and a novel inspired by his life and work called *Outside In*. I hope these stories serve as good starting points for understanding the extraordinary spirit and talent of Nek Chand, but I'd encourage you to learn more. At the Nek Chand Foundation website (nekchand.com), you can view his art, read about his life, and join the work of the foundation to support and preserve the genius and spirit of the Rock Garden. A portion of the proceeds from this book's sale will also be donated to the foundation.

Finally, I am deeply grateful to Neera and Vinod Puri, John Francis Cross, and Anuj Saini for reading and commenting on this story. Thank you.

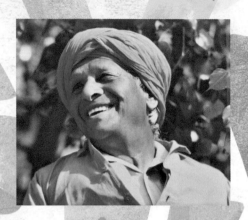
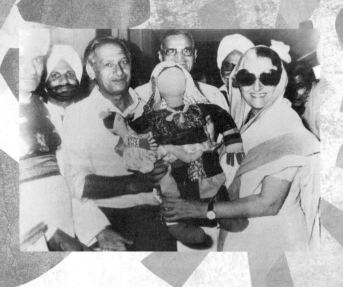

TIME LINE

1924 Nek Chand Saini is born north of Lahore. Lahore was once part of India but is now the second most populated city in Pakistan.

1947 India gains independence from Great Britain, but the Punjab region where Nek lives is divided and West Pakistan created. Nek and his family are among the ten million refugees who are forced out by violence and unrest as a result of the creation of the new country.

1950 Nek Chand marries Kamla.

1951 Nek and his wife settle in Chandigarh, the new capital city of the Punjab state in India. Architect Le Corbusier designed and oversaw the construction of the carefully planned city—the first of its kind in India. Nek is hired by the city as a roads inspector.

1955 Nek and Kamla's daughter, Neelam, is born.

1958 Nek begins secretly building his sculptures and working on the unused plot of land at the edge of the growing city.

1964 Nek and Kamla have a son, Anuj.

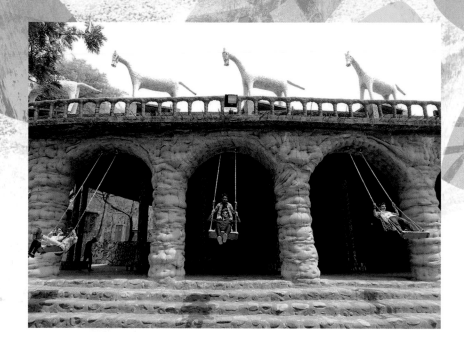

1975 Nek's garden is discovered by the authorities. While many are furious at what he has done, many are enchanted. He is invited to meet with the Indian prime minister, Indira Gandhi. The work to protect and grow his creation begins.

1976 The Rock Garden opens to the public, welcoming visitors for the first time.

1983 Nek is honored with a postage stamp bearing the image of some of his sculptures.

1984 Nek is awarded the Padma Shri by the government of India for distinguished service to the arts.

1990 Authorities in Chandigarh decide to build a road through the garden. A grassroots protest movement is born, and over a thousand people—many of them children—form a human chain around the garden walls to stop the bulldozers.

1997 The Nek Chand Foundation is established to help protect and support the Rock Garden. Nek continues working and overseeing the development of the garden.

2015 Nek Chand dies in Chandigarh.

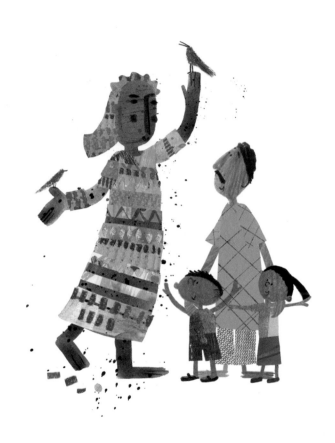